DF

500

FABULOUS FLOWERS

A Sketchbook for Artists, Designers, and Doodlers

LISA CONGDON

QUARRY

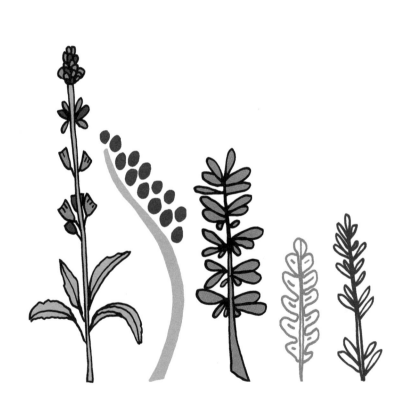

HOW TO USE THIS BOOK

This book features 500 drawings of fragrant florals, buds, and blossoms sure to delight your senses. You will see that most of these drawings are comprised of simple combinations of lines and shapes. When you look at a flower you want to draw, what do you see? Are there squares, circles, or triangles? Are the outlines of the shape straight, curved, or wiggly? When drawing a dandelion, sunflower, or tulip, look for the big shapes and lines first, and then add in the smaller details.

Use the illustrations in this book as inspiration. You can trace them, copy them, or change the details to draw your own versions. There's plenty of blank space to draw right in the book, so grab a pencil, pen, marker, or brush, and have fun drawing lots of flowers, real or imagined, of your very own!

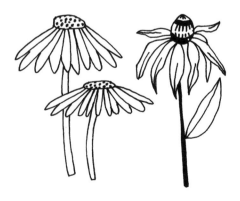

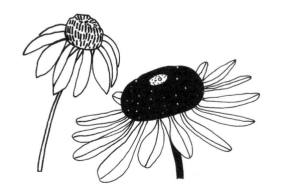

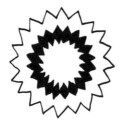

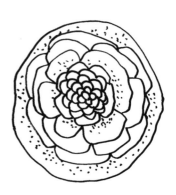

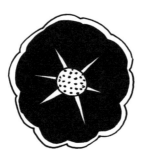

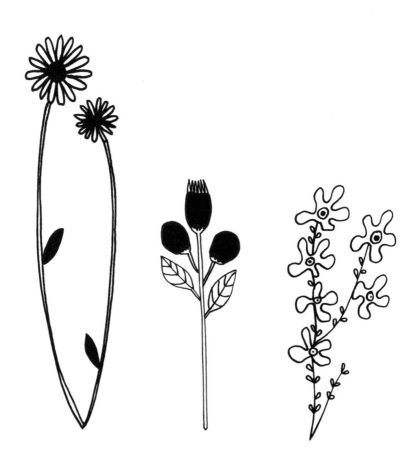

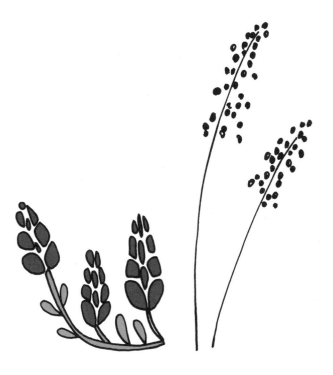

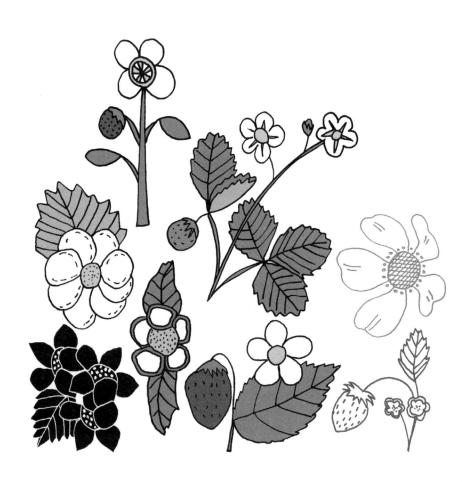

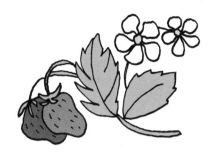

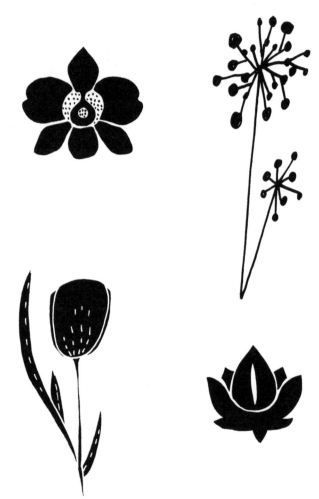

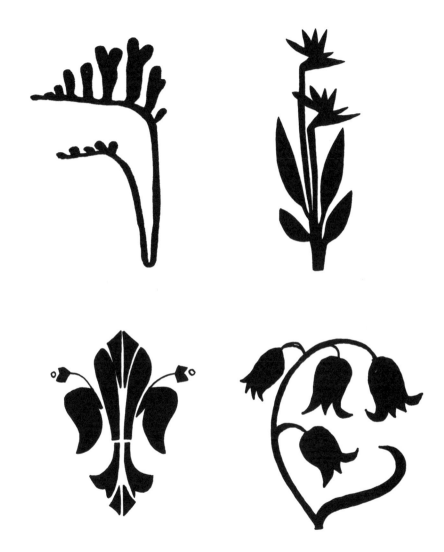

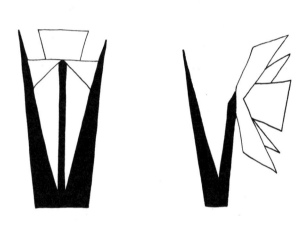

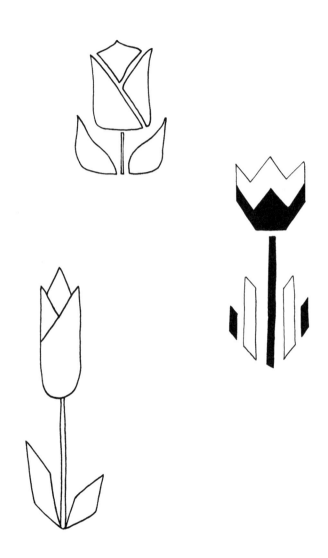

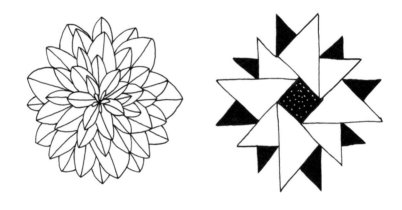

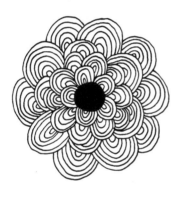

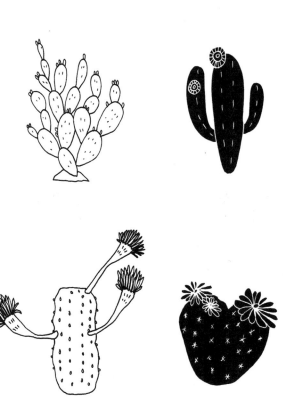

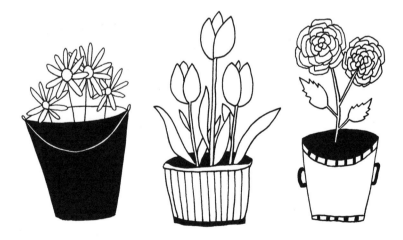

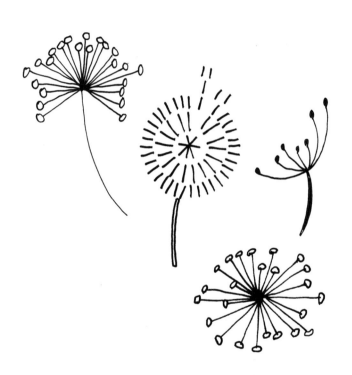

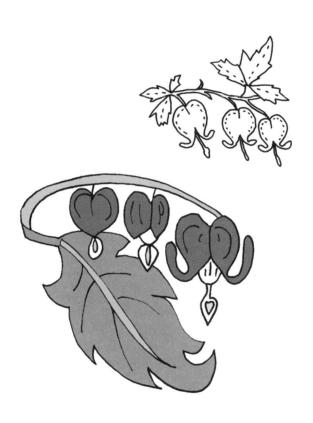

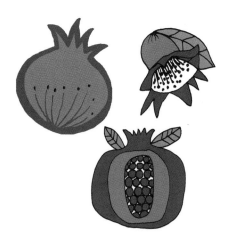

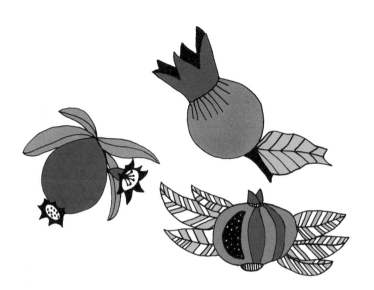

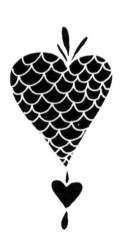

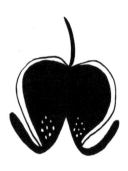

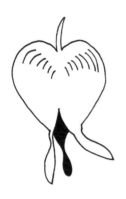

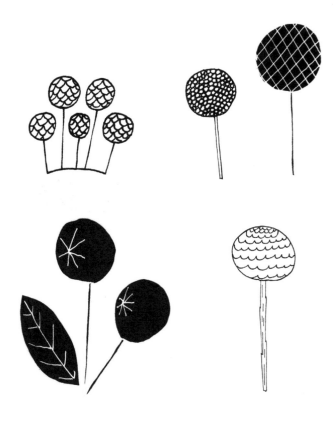

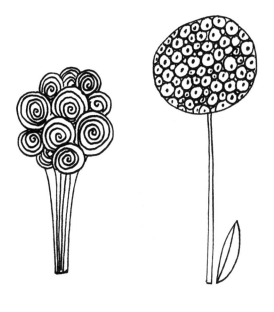

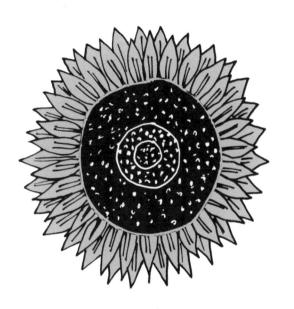

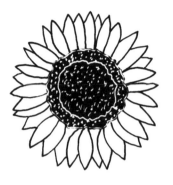

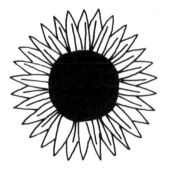

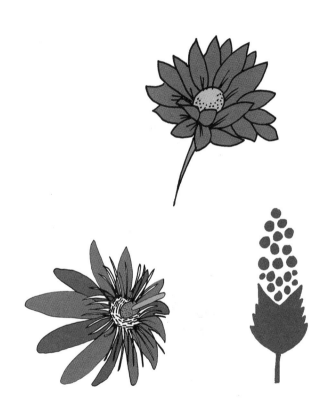

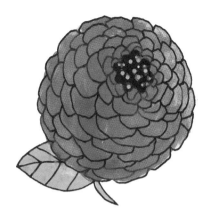

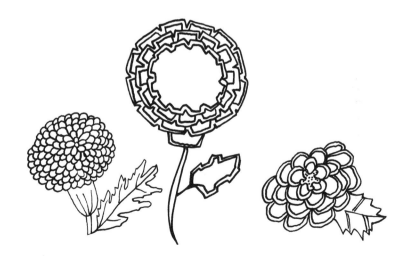

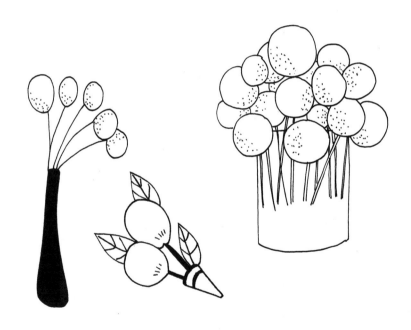

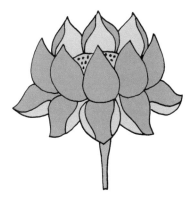

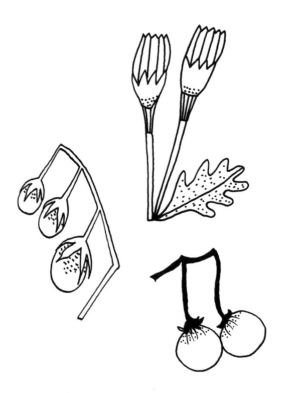

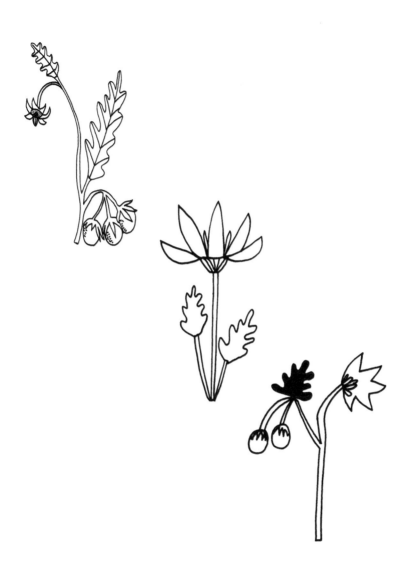

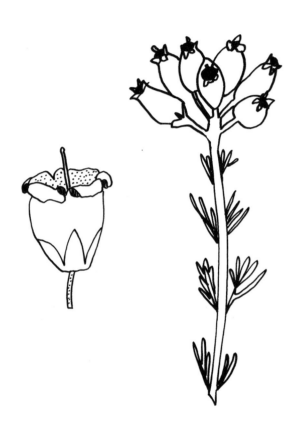

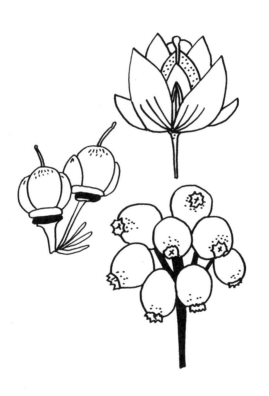

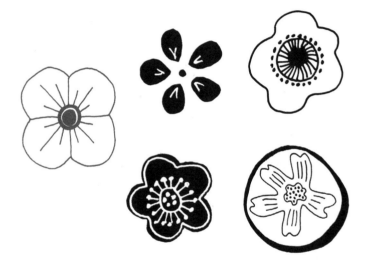

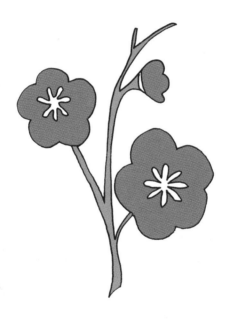

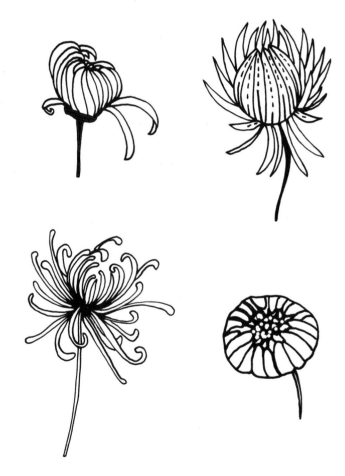

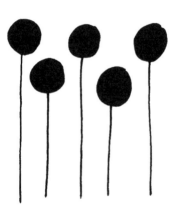

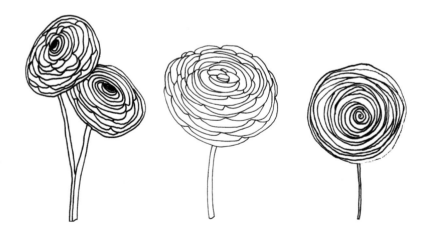

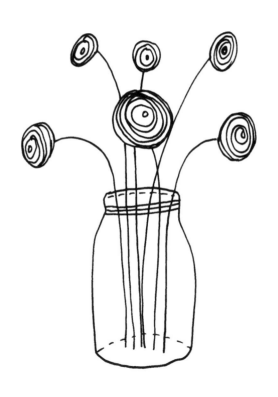

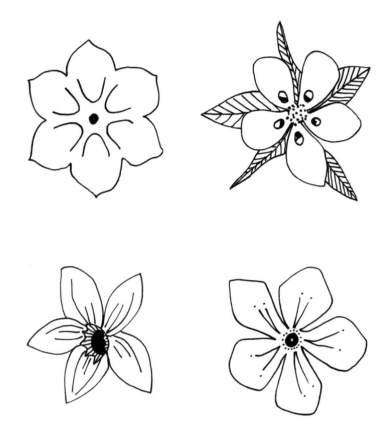

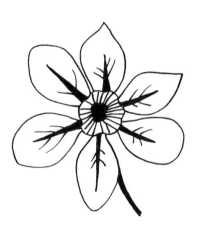

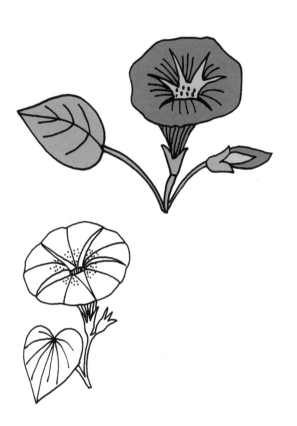

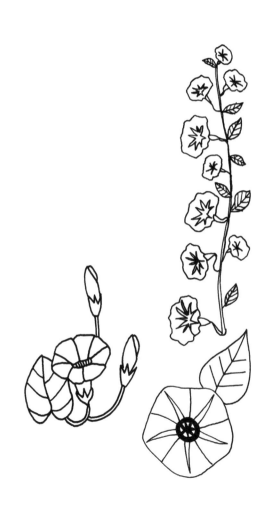

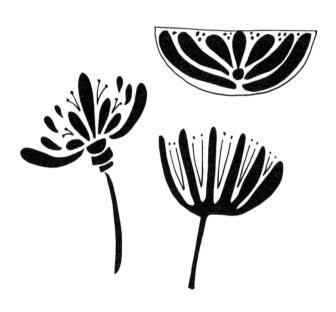

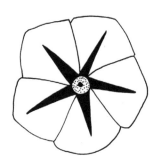 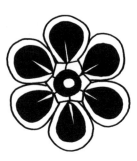

 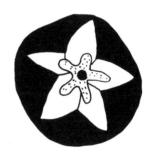

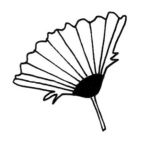

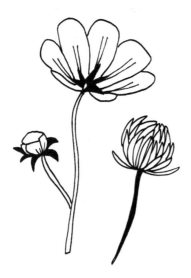

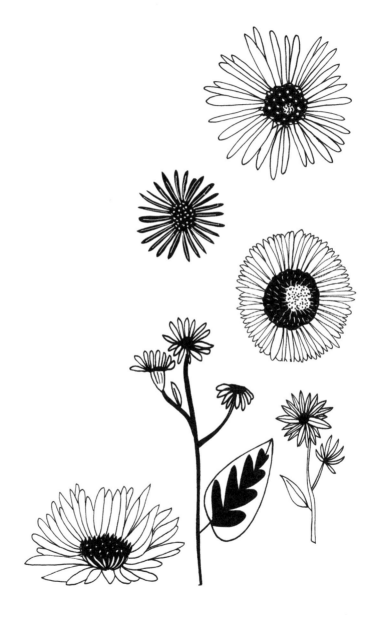

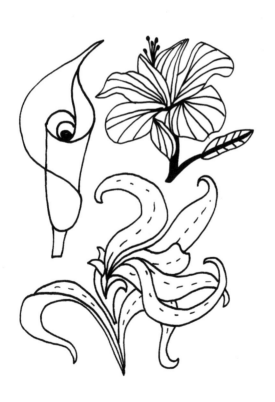

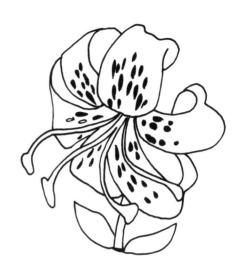

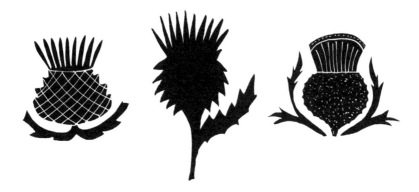

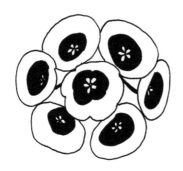

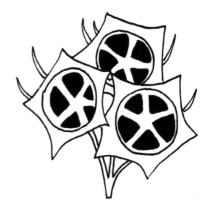

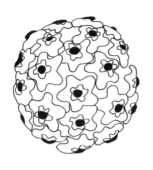

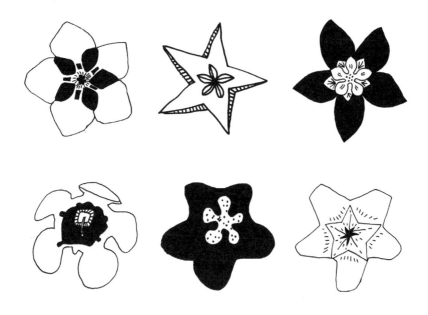

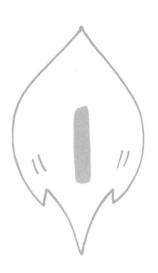

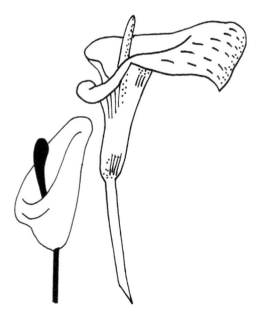

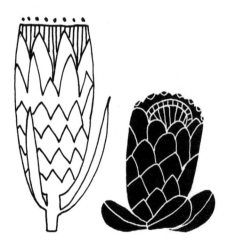

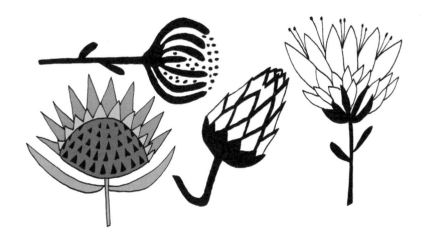

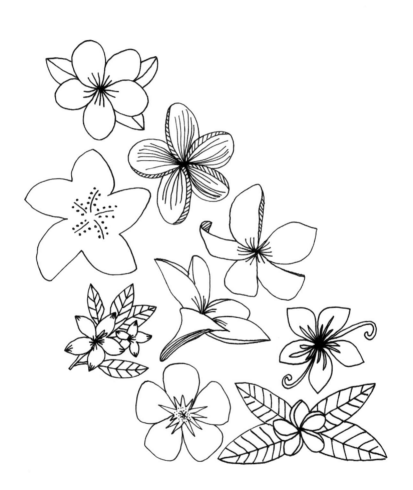

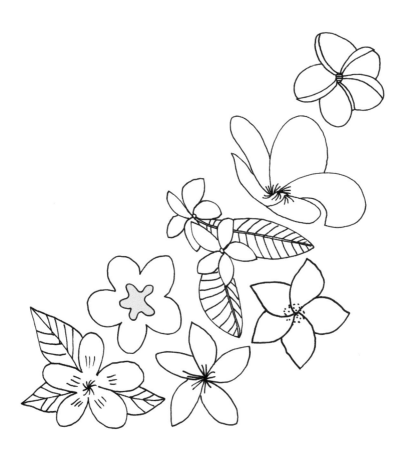

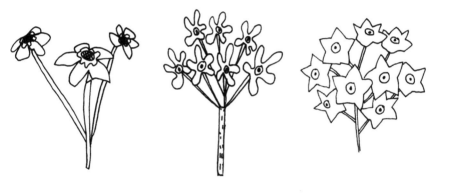

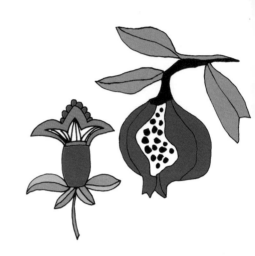

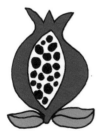

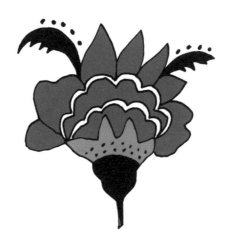

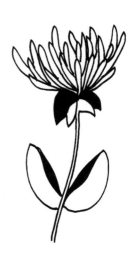

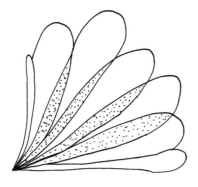

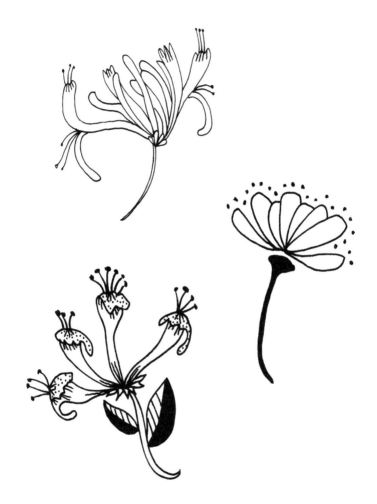

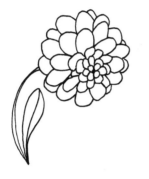

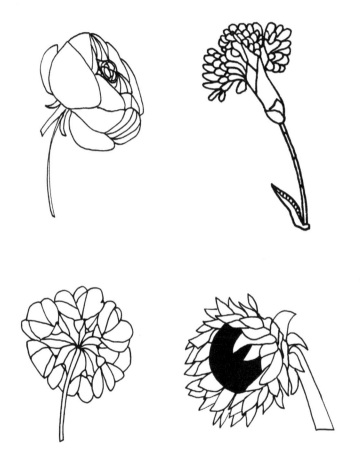

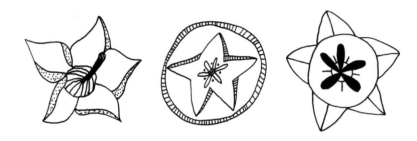

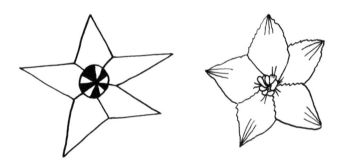

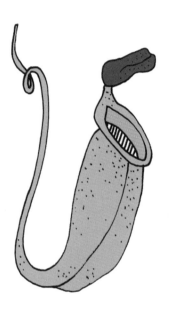

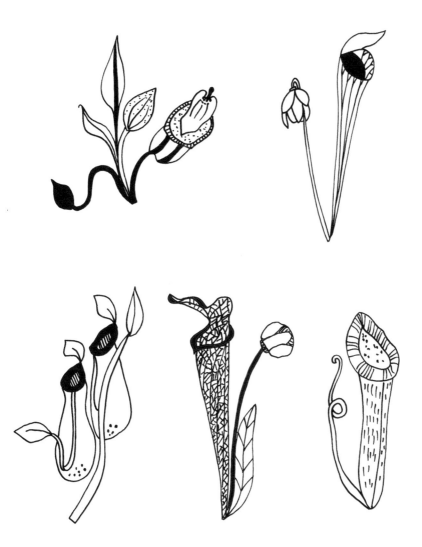

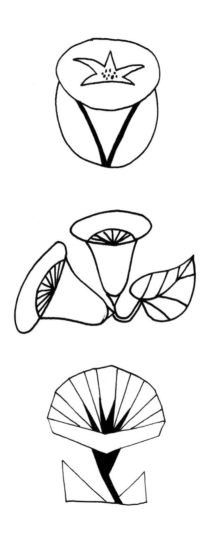

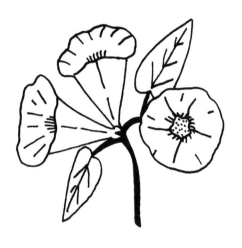

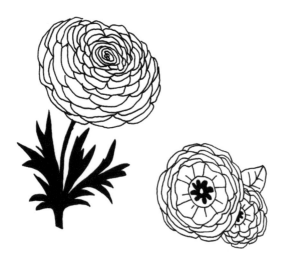

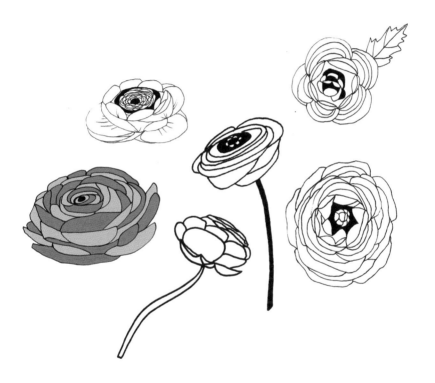

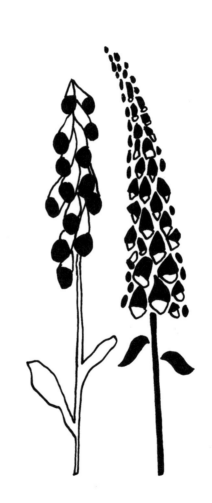

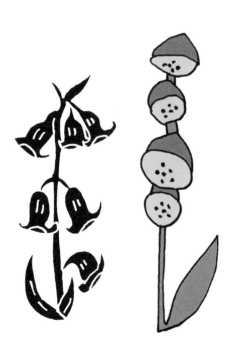

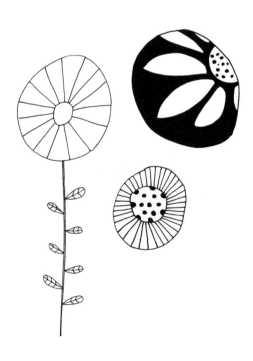

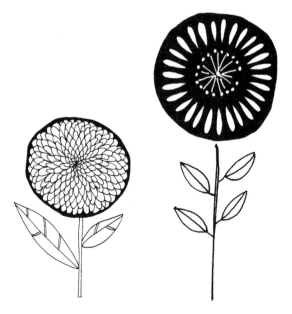

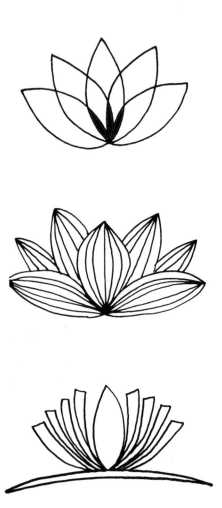

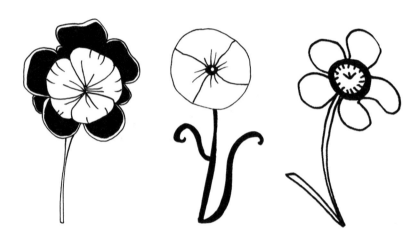

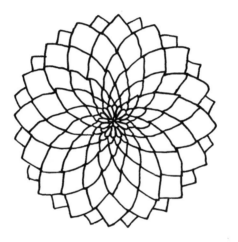

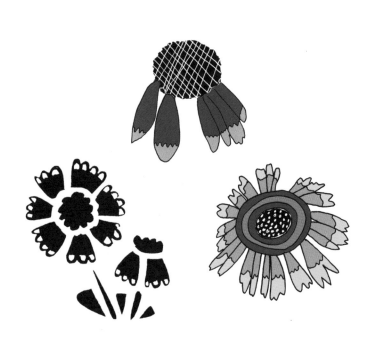

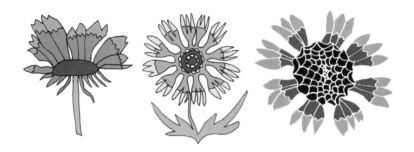

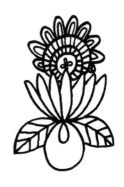

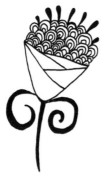

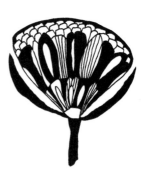

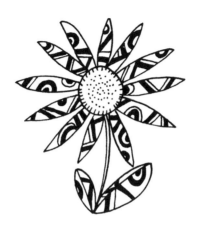

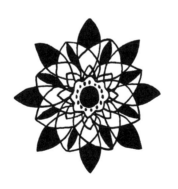

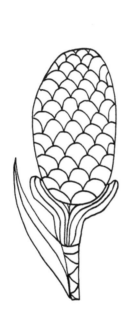
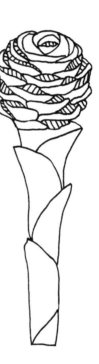

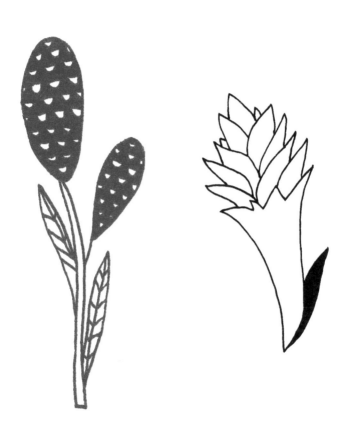

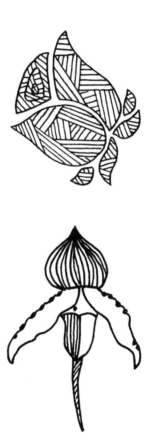

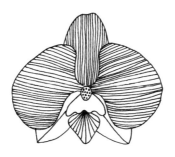

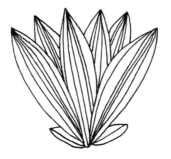

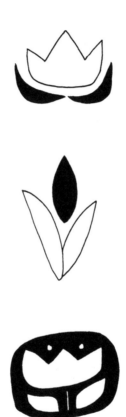

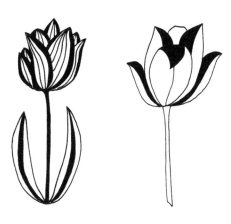

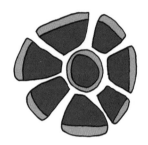

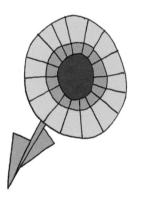

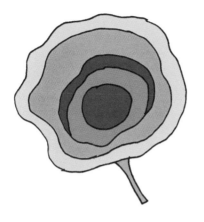

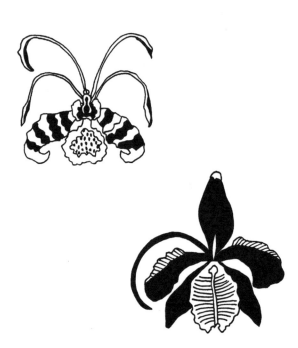

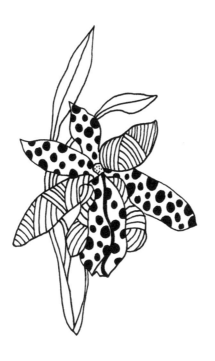

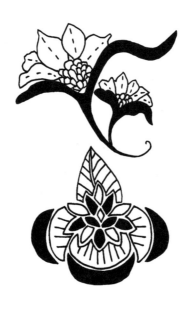

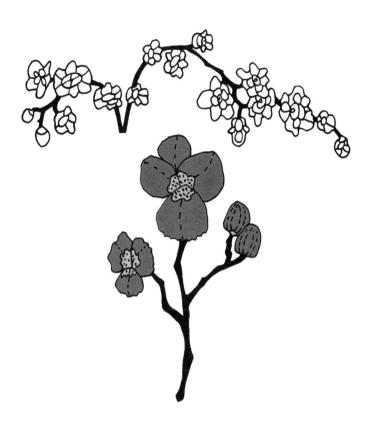

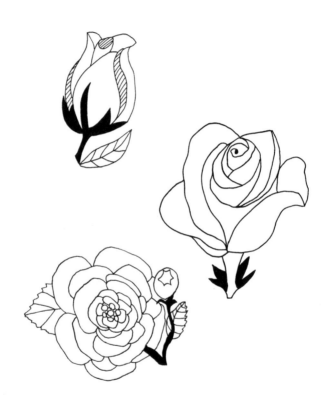

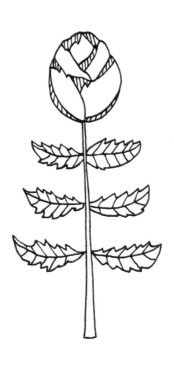

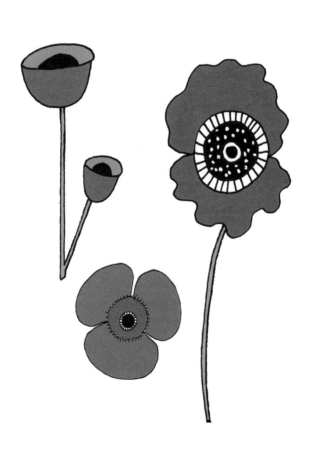

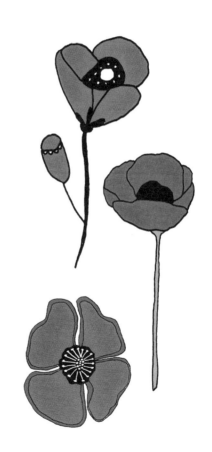

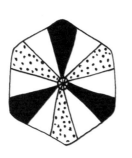
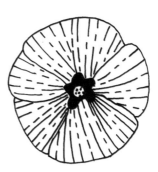

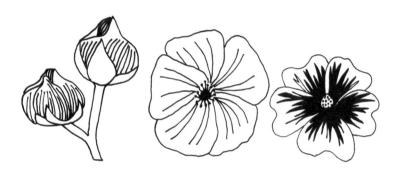

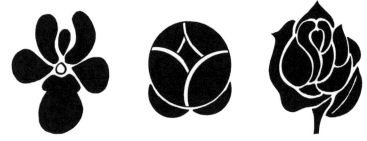

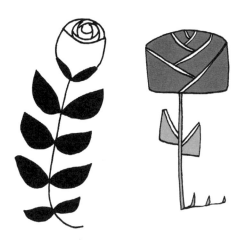

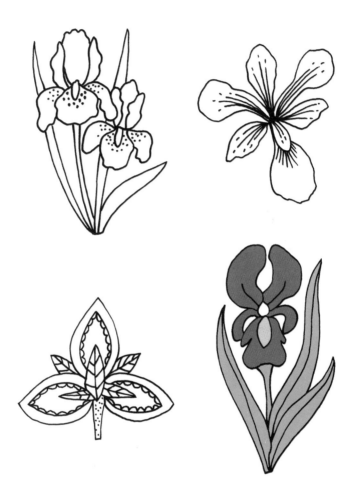

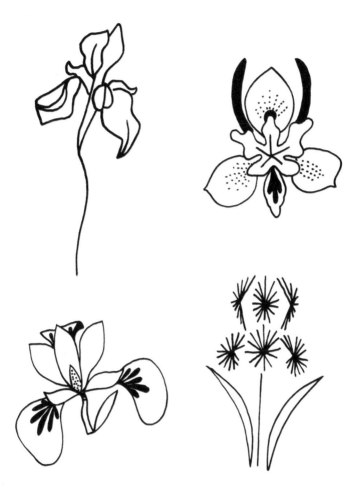

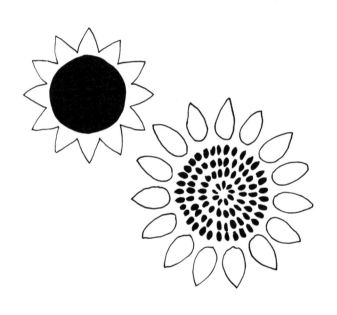

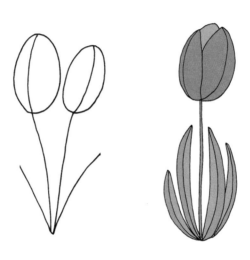

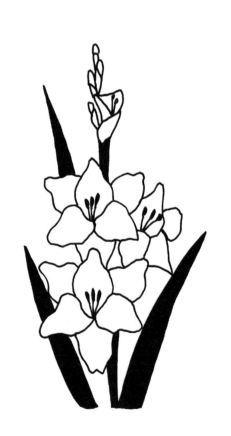

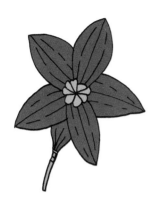

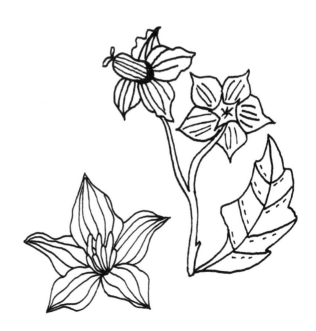

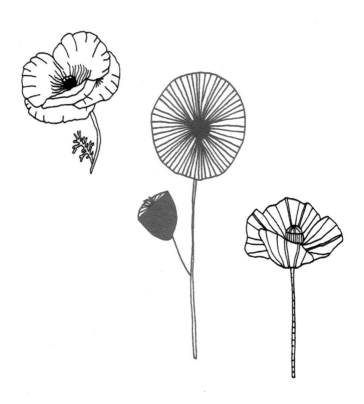

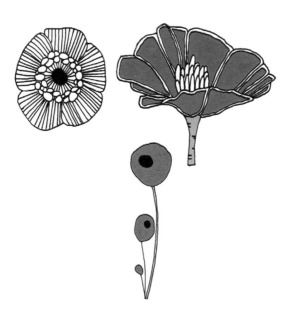

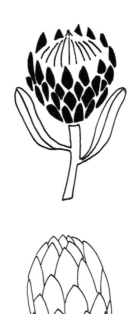

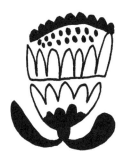

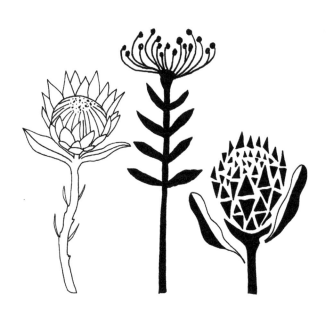

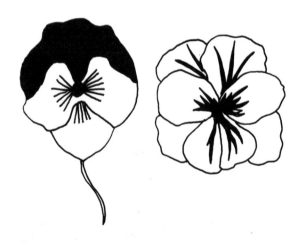

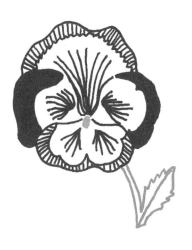

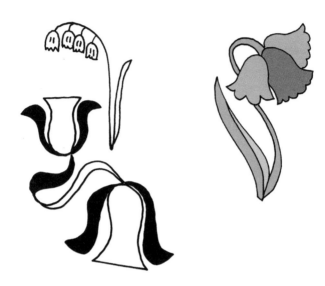

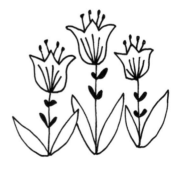

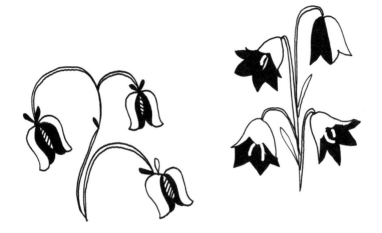

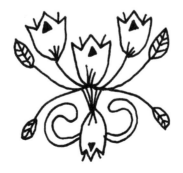

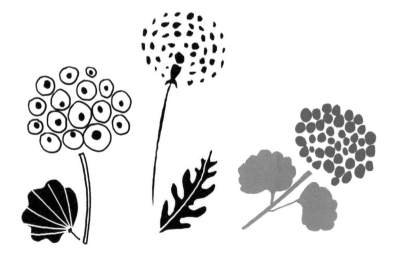

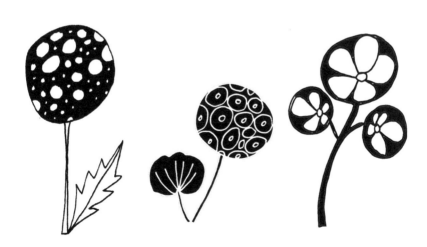

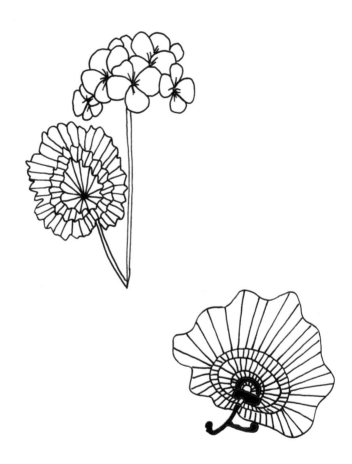

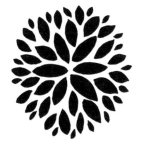

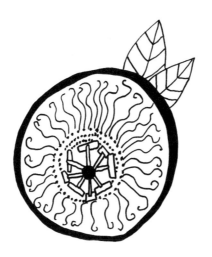

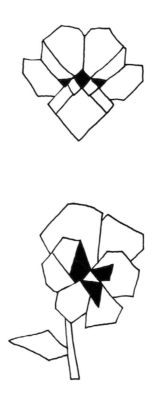

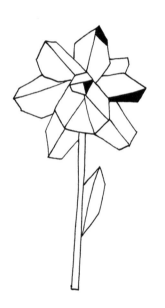

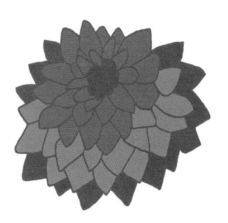

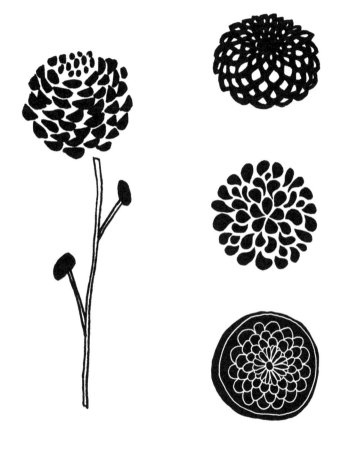

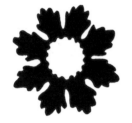 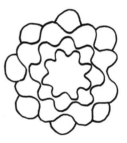

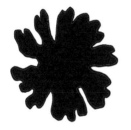 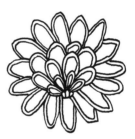

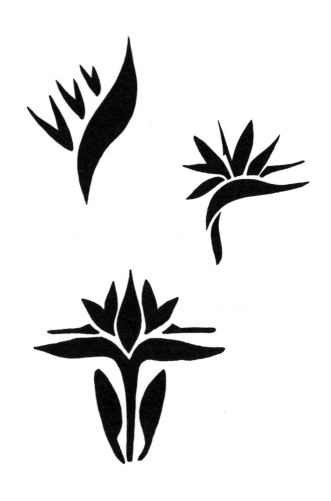

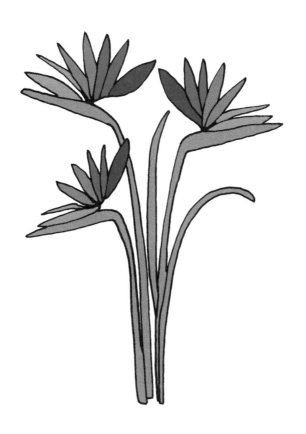

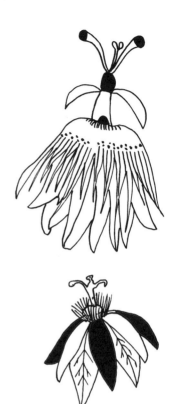

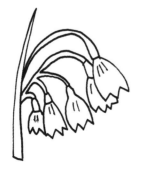

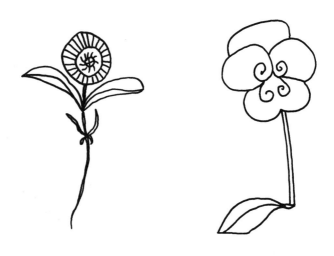

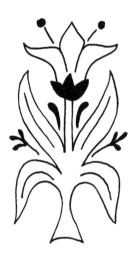

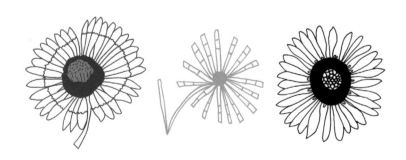

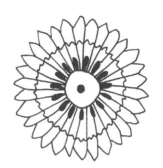

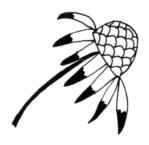

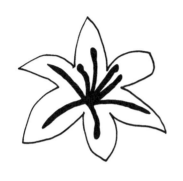
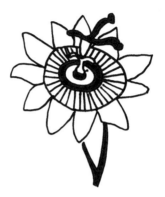
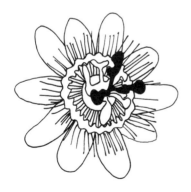
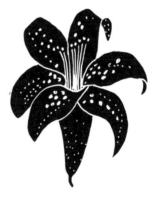

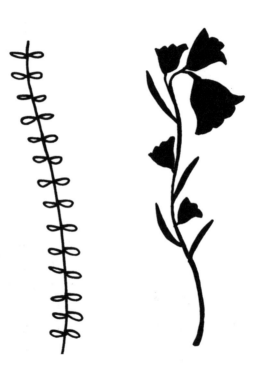

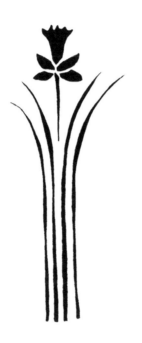

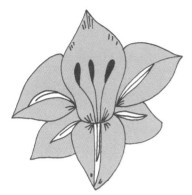

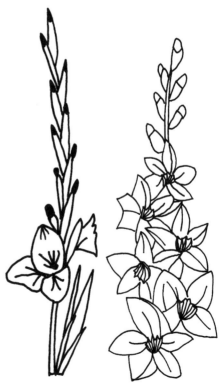

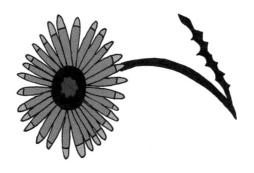

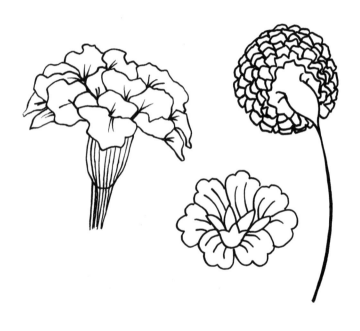

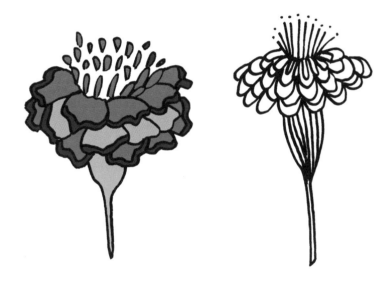

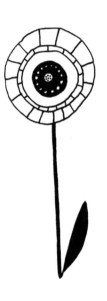

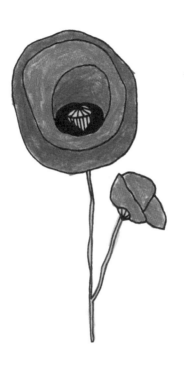

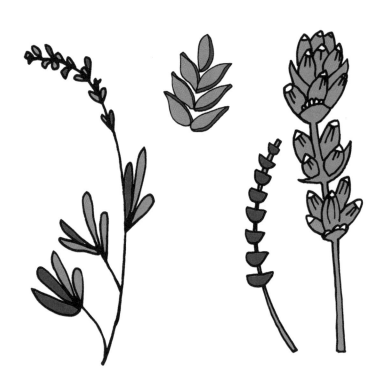

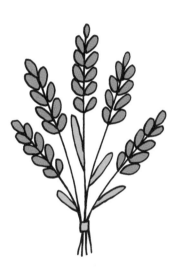

ABOUT THE ARTIST

Fine artist and illustrator Lisa Congdon is best known for her colorful and detailed paintings and drawings. She enjoys hand lettering and pattern design, and keeps a popular daily blog about her work and life called "Today is Going to be Awesome." Lisa's clients include Quarry Books, Chronicle Books, Simon & Schuster, and the Museum of Modern Art, among others. She lives and works in Oakland, California. To see more of her work, visit Lisa's website at **www.lisacongdon.com**.

Inspiring | Educating | Creating | Entertaining

Brimming with creative inspiration, how-to projects, and useful information to enrich your everyday life, Quarto Knows is a favorite destination for those pursuing their interests and passions. Visit our site and dig deeper with our books into your area of interest: Quarto Creates, Quarto Cooks, Quarto Homes, Quarto Lives, Quarto Drives, Quarto Explores, Quarto Gifts, or Quarto Kids.

First published in 2014 by Quarry Books,
an imprint of The Quarto Group,
100 Cummings Center, Suite 265-D,
Beverly, MA 01915, USA.
T (978) 282-9590 F (978) 283-2742
www.QuartoKnows.com

Quarry Books titles are also available at discount for retail, wholesale, promotional, and bulk purchase. For details, contact the Special Sales Manager by email at specialsales@quarto.com or by mail at The Quarto Group, Attn: Special Sales Manager, 401 Second Avenue North, Suite 310, Minneapolis, MN 55401, USA.

10 9 8 7 6 5 4 3

ISBN: 978-1-59253-991-8

All artwork compiled from *20 Ways to Draw a Tulip and 44 Other Fabulous Flowers*, Quarry Books, 2014

Design: Debbie Berne

Printed in China

MIX
Paper from responsible sources
FSC® C016973